A memoir would be,
for someone with a better memory
than me.
Instead of memories,
I have pieces of poetry
and snap shots of reality.

Morning Fiction

Woke up,
Downed the rest of a flat, warm Orange Crush,

Grabbed the gear on the floor,
and clothes to change
in the car,

Headed out the wooden door of our one bedroom.
Road tripping all the way down to the town.

fell out onto the ground,

stooped down,

rewound,

and found

gravity to be hanging upside down.

Closer to the edge morning weeps,
Moss willows over everything,

Turning dust into dirt
and golden into ashes

morning resurfaces with her face washed as clean

as she.

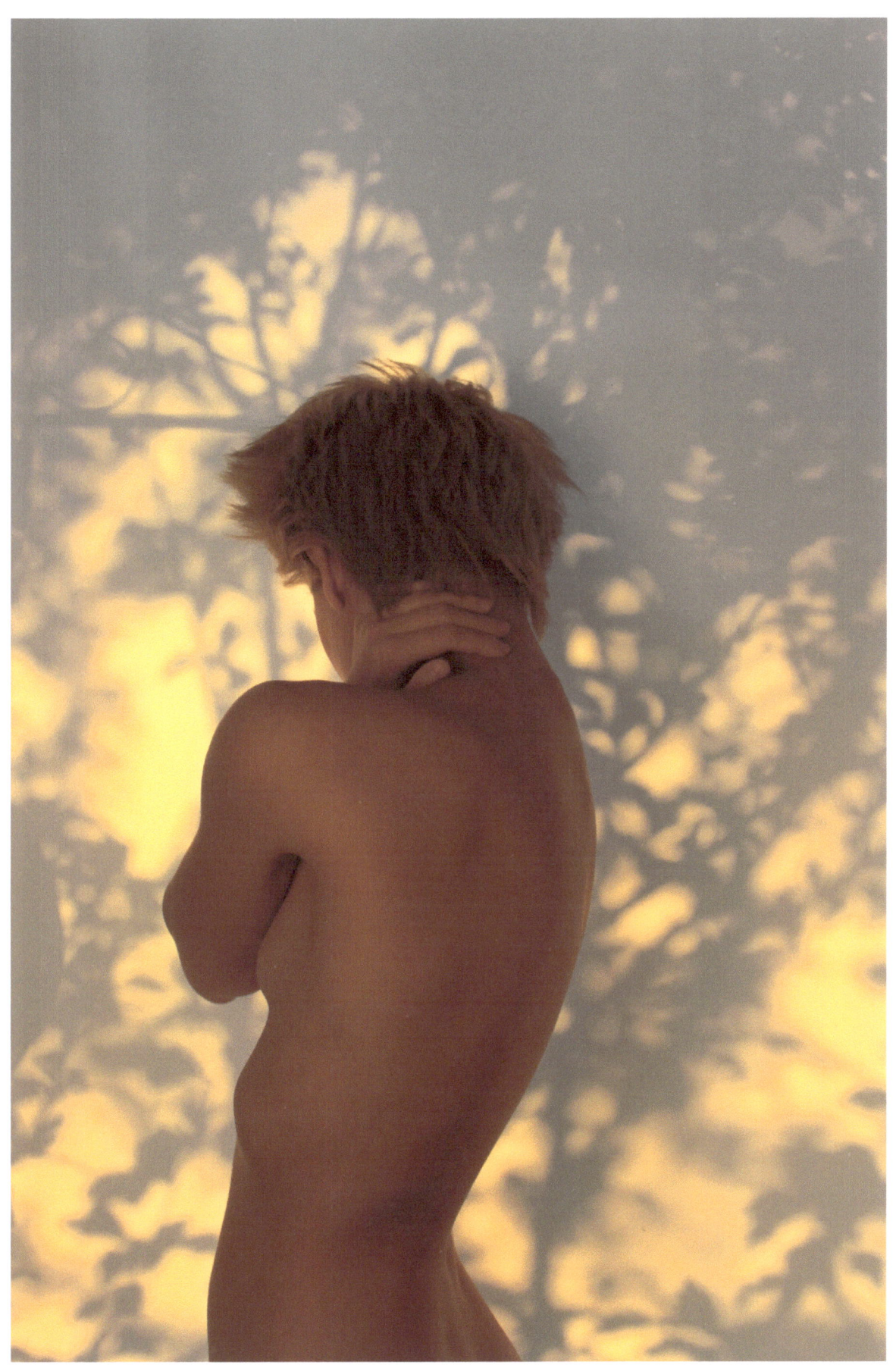

Wine Hit Faces

Drudging up from the dark muck,

Merging back from the night-life.

Liquid lining.

Sardonic obscurity redresses the lawless body,

Hides the goods of the intention

Saws the planks from the copy

Creative side

 has run flat,

 dry

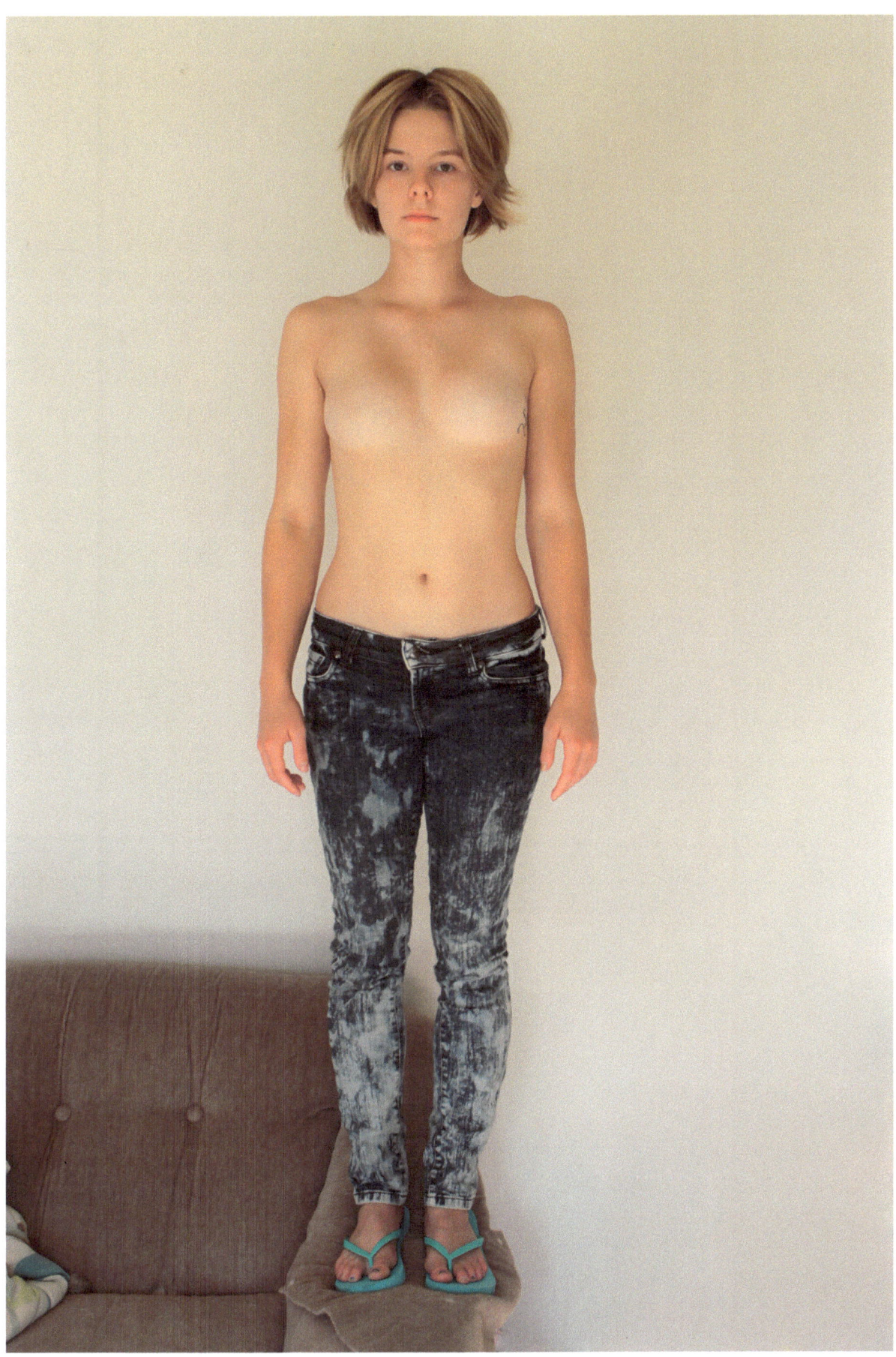

Entropy
Sisyphean

Starlight -54
The circumference of the earth is
Which brings me a little closer to you

Full body nightmares aren't as warm as they seem
or is it just poison in my dreams

Internet Poetry isn't as sweet
As fresh laid ink

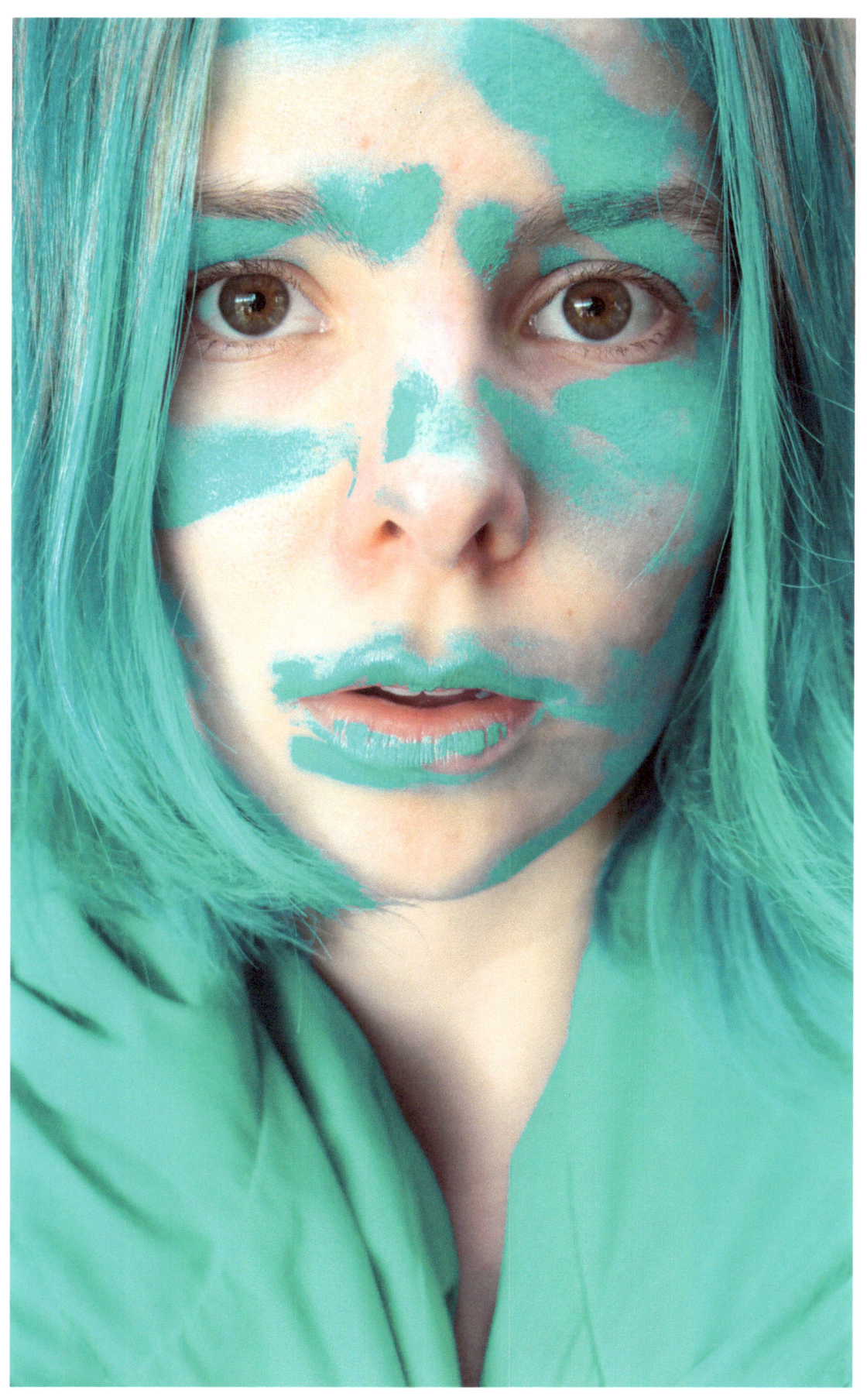

--A Random Case of Shoe Laces--

Minute particles fall from my fingers
onto everything I touch.
Small and multi-colored,
I dye my hair too much.
Maybe it is
I never have to fit the role,
the skin,
I am sentenced to in.

The warping shape of my body fits carefully against wooden chairs.

Life is not love,
But a ghost inherited.

Decrepit little fingers
march their life on piano keys.

As I plunk along,
a song that no one knows,
dark and meaningless as the strings on my shoes.

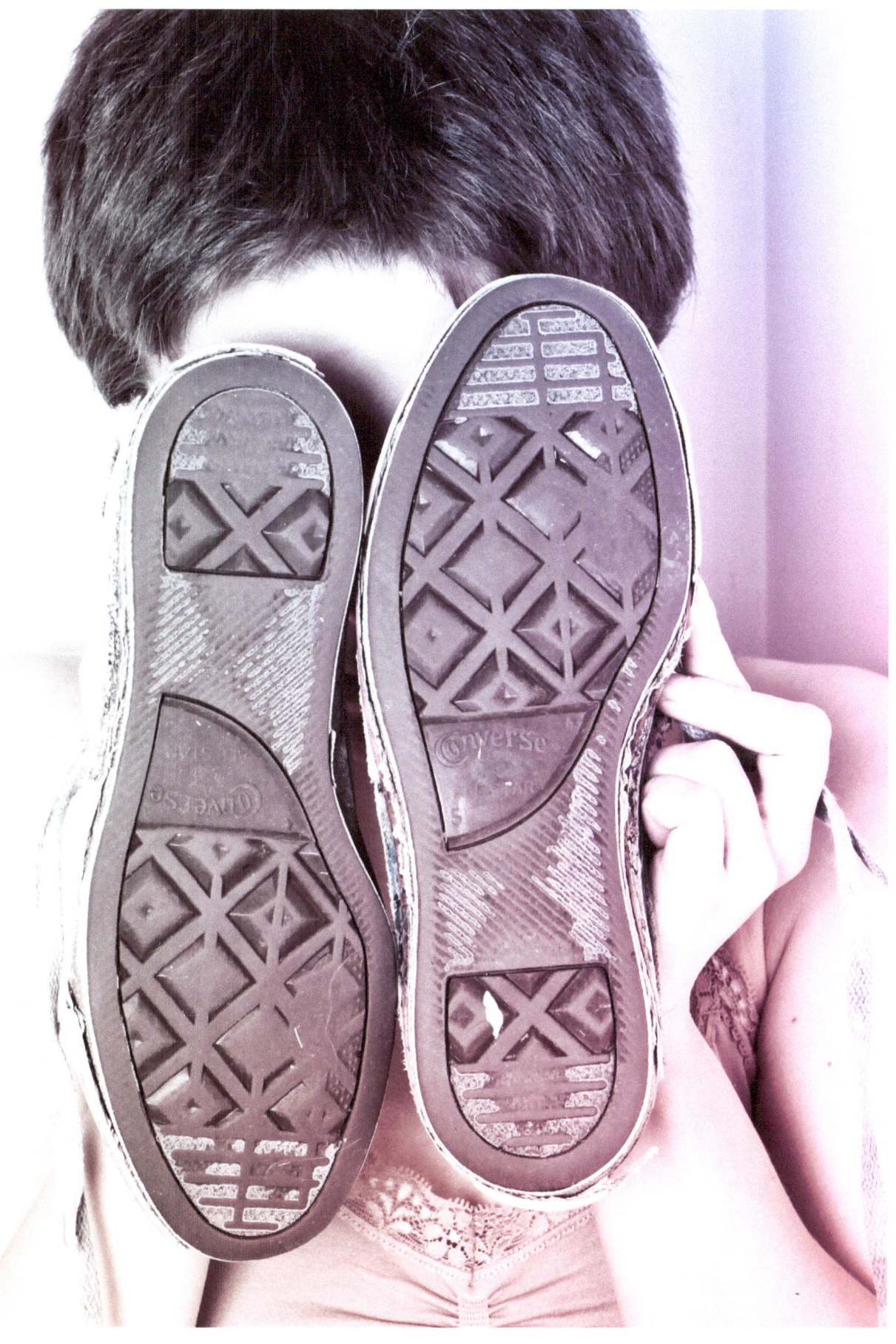

Ink Pen

Pen plunged into the vein,
Black ink winds throughout the room,
Penetrating the body that holds the story.

[Spreads.]

Arteries know the answer
why this world is full
of an unending cancer.

City streets are where you find
little girls who cut off their minds.
Their hands unbindingly tied.
Long lost in the prophet-less desert time.

Then, "Sing me to sleep with iconic dreams"
Said like a one no longer here.

Dear,

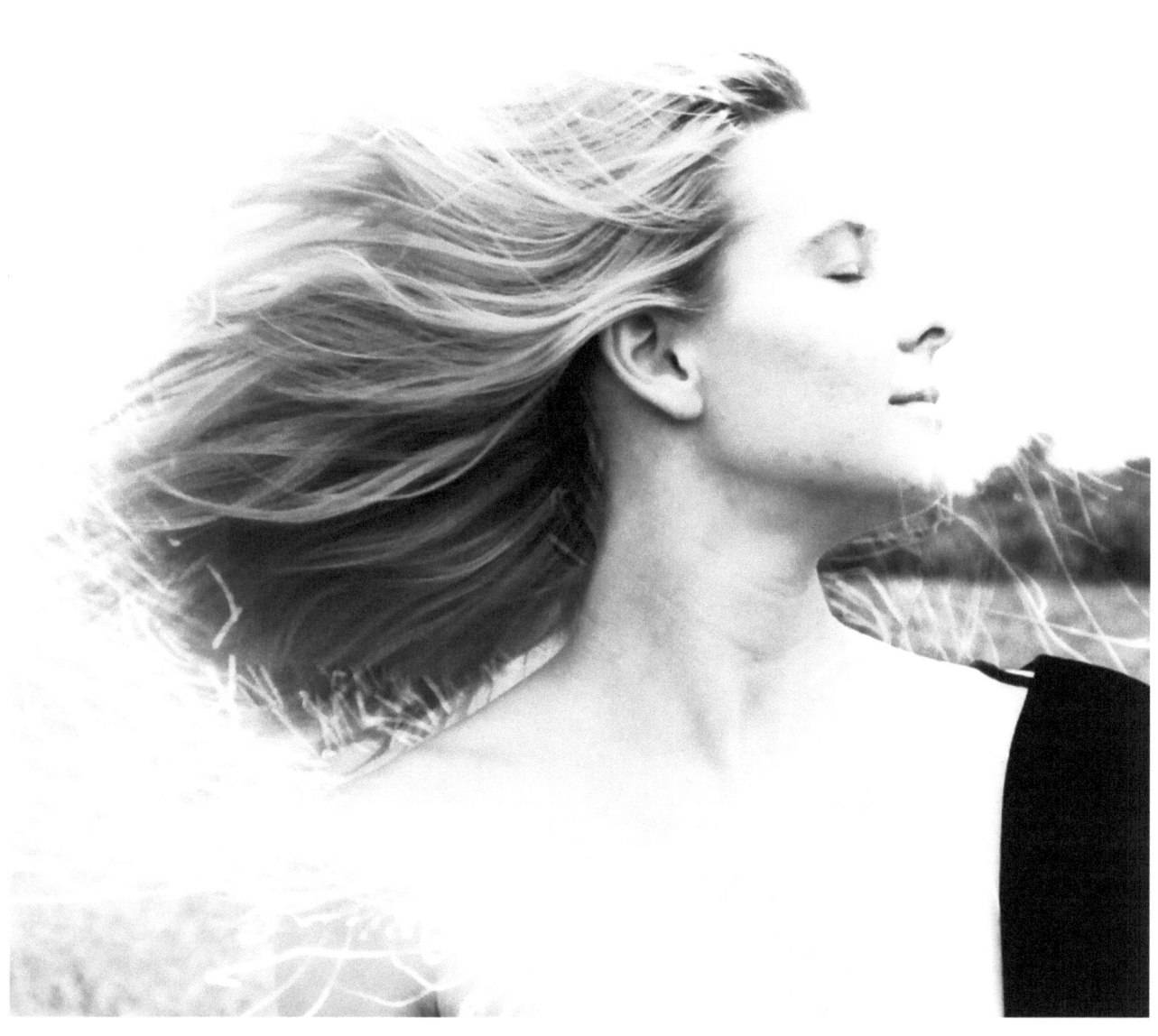

Rogue Letters

You remind me of dried up poetry,
with your subtle lines,
each leading, to the next.
The way your hair winds
round my fingers and twists
into roots leading to small
rose veins.

Rouge the sheets,
but not of sleep
but of a hot hot heat.

Our history is written
in the trees.

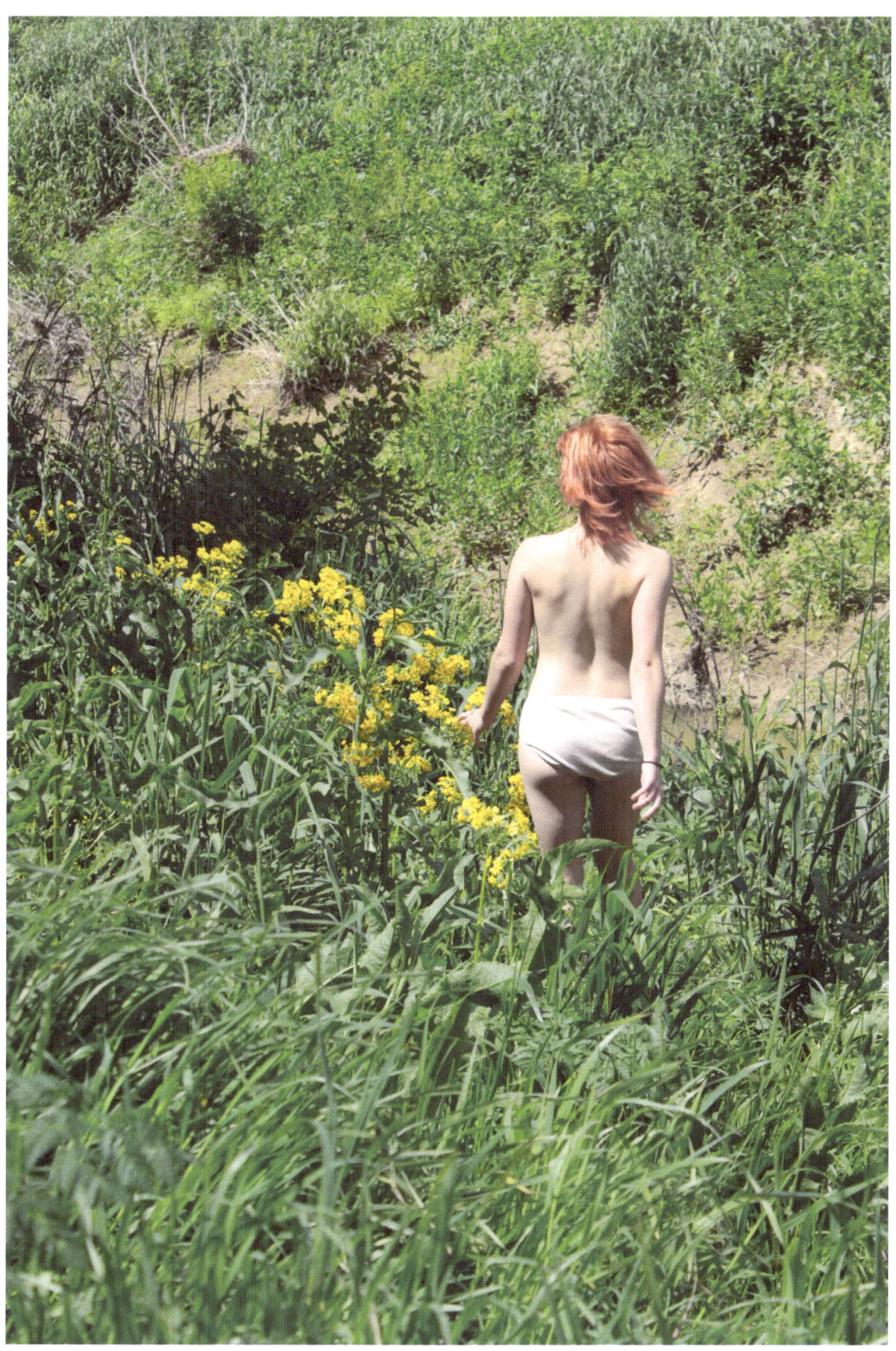

Phase Phage

Strings like green beans
The suspension of cloudy butterflies in the air

Celery crunch of the plain girl
Suspended from her summer hair

The hole in your dress is an ornate purple flower.
The hair always unkempt is as windswept as it comes.

Crunch the snow of feet
Dew or morning mist
Elongated Fingertips
And unmarked breath phrases

The curve of the chasm.
Reaches its hands.
Forming a foam structure
of
contemplatence and fragility.

Extra English fills their sheets.

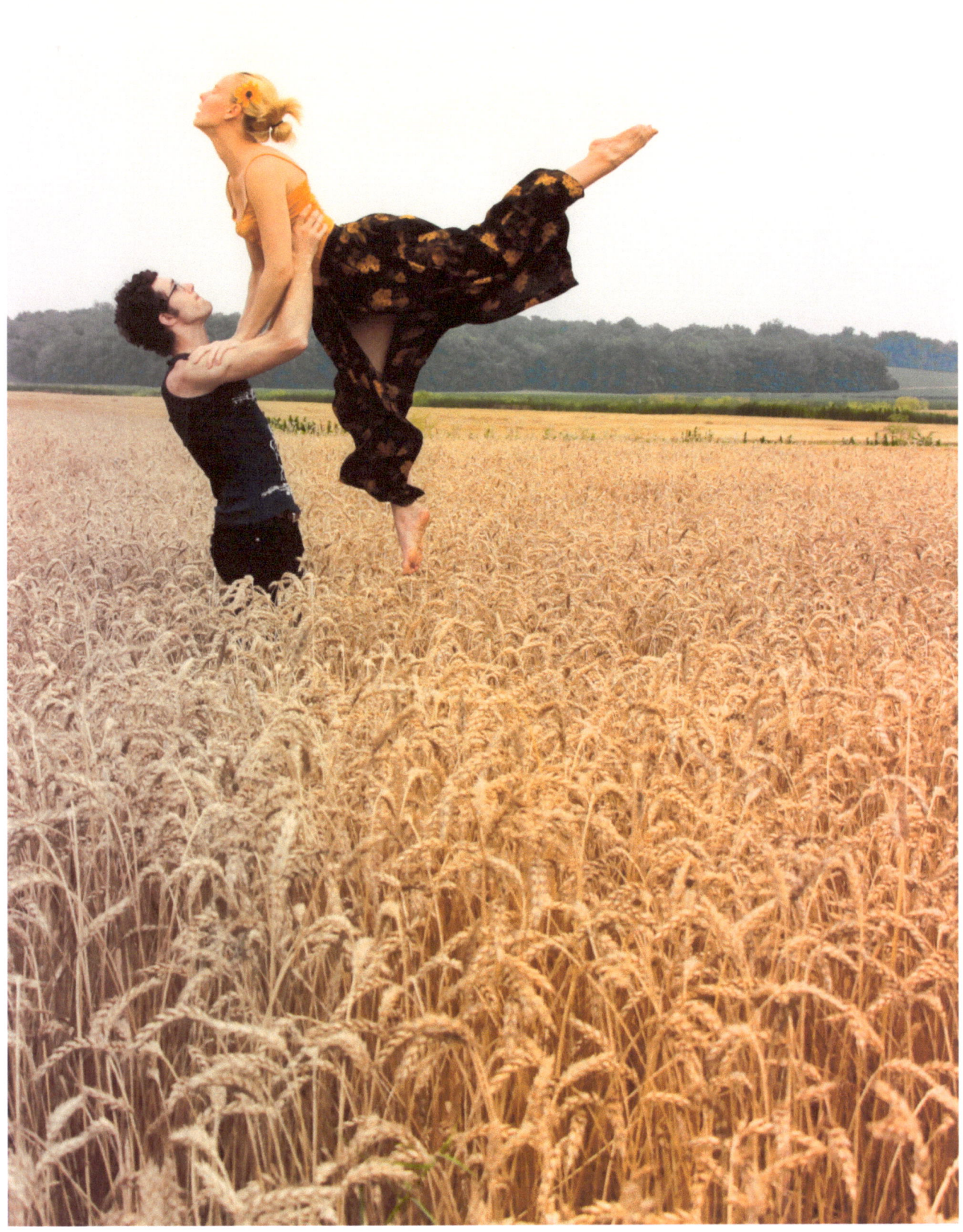

Sunlight Makes Me Shudder

Decay, decompose, compromise the little girl.

White flowers, and lilies dance in and out of the field poppies
replace the sun flowers, dizzi instead.

Start to run.

Away from the break of day, sunlight sweeps away.
Into an occur of beautiful bliss
unconcerned
as we go on a quest for a far away land
filled with steam and land fill flies
beauties side by side
our quest of four countries.

Run under ground
into hard harsh awry.

sea shore
that we break
by day.

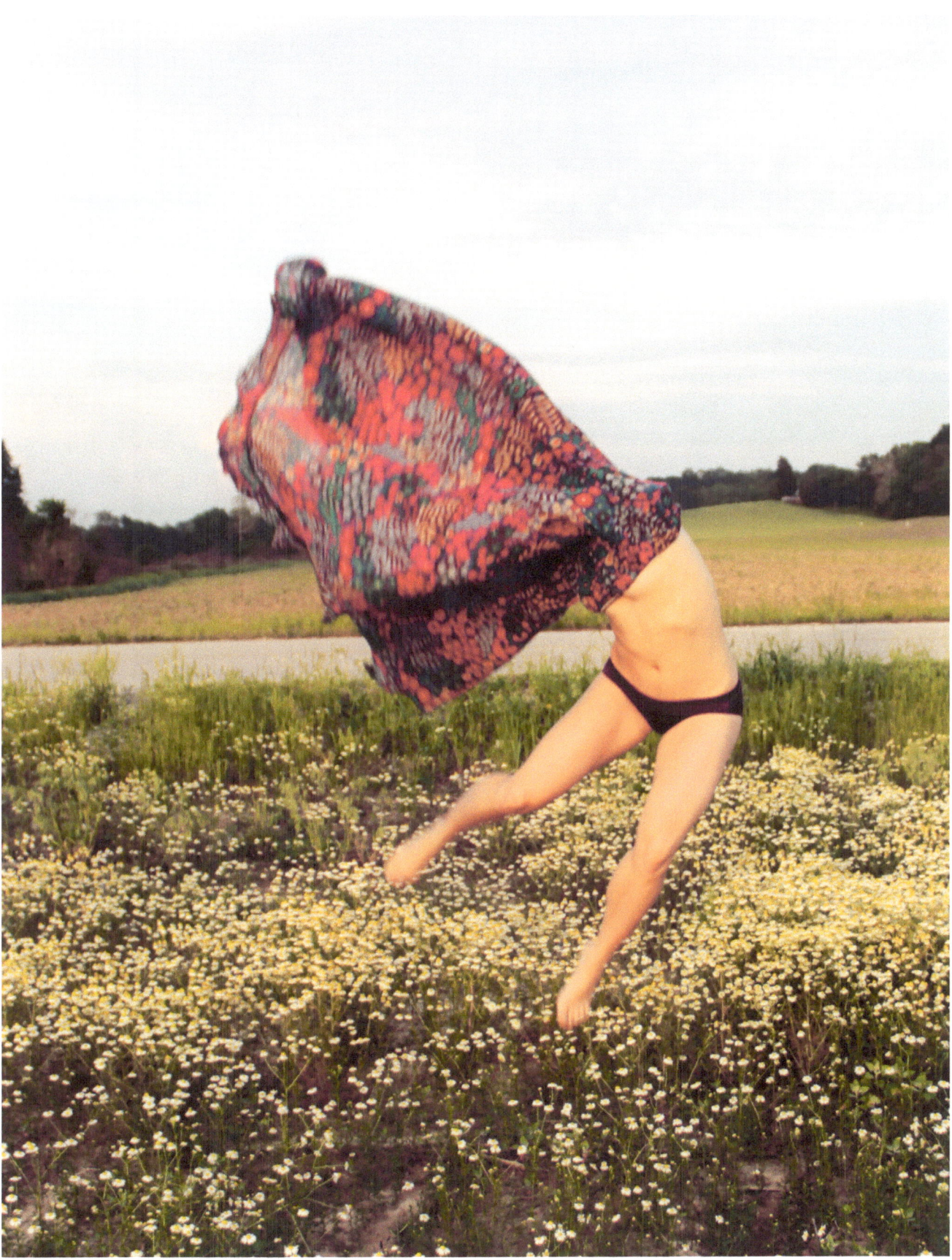

The Street

The spark of light
brings power to
the skies.

Winds of summer
circle the trash encrusted
back lit streets.

Dirty.

The World.

Stealing ideas from
beneath street lamps.

Searching for anything new,
distinct.

When the world has lived
and the world has died.

Why do we
try to reach
heavenly heights?

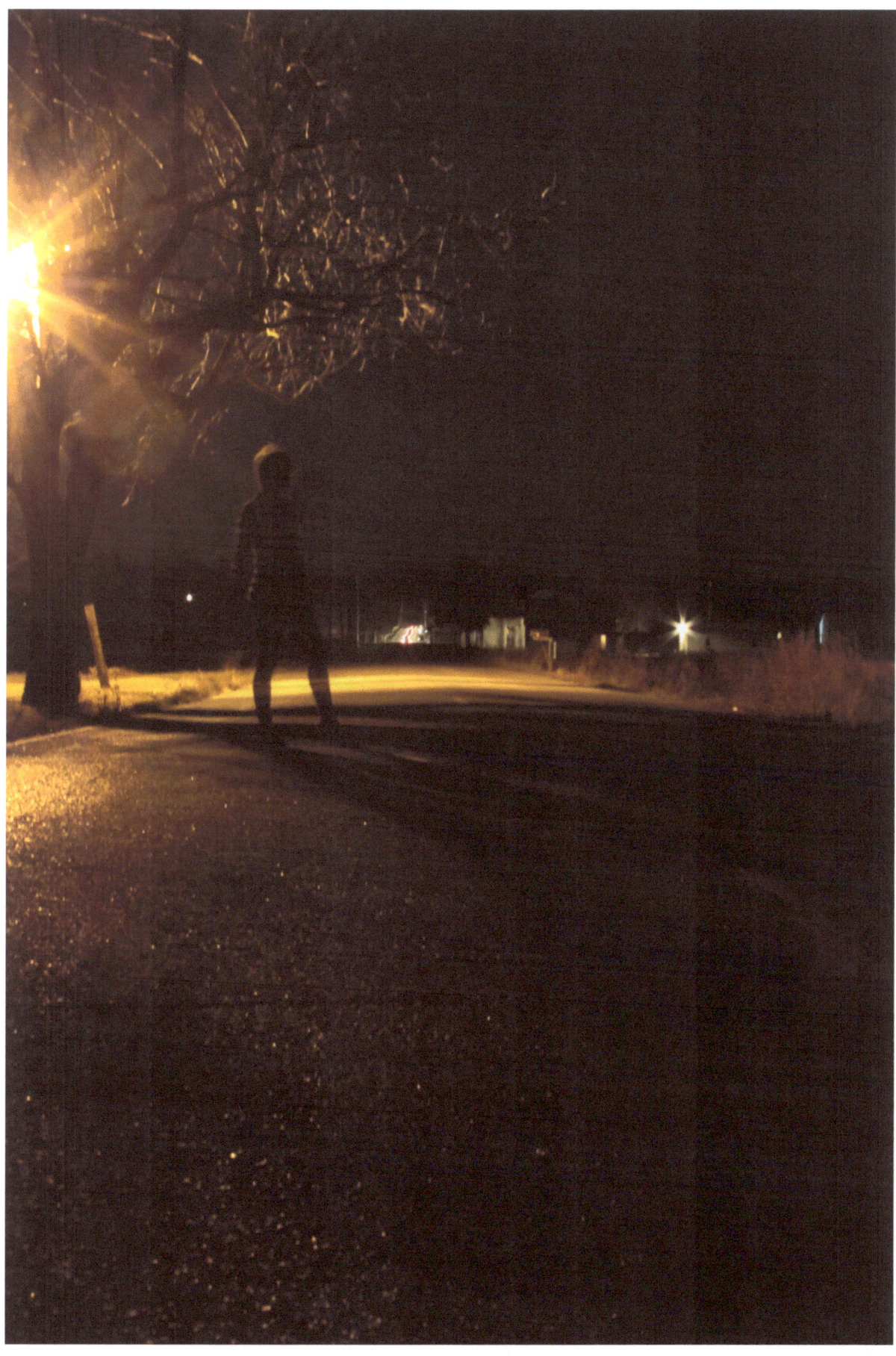

Naked Sleep

Catharsis before bed
the ensure of lucid dreams.
Crayons and coffee breaths
pass hours on
but only count
as one reading.
of people being.

Naked and free, this is how you will define me.

Shoulder blades
open wide.
To put an island to sleep.

Aquatic life falls into dreams.

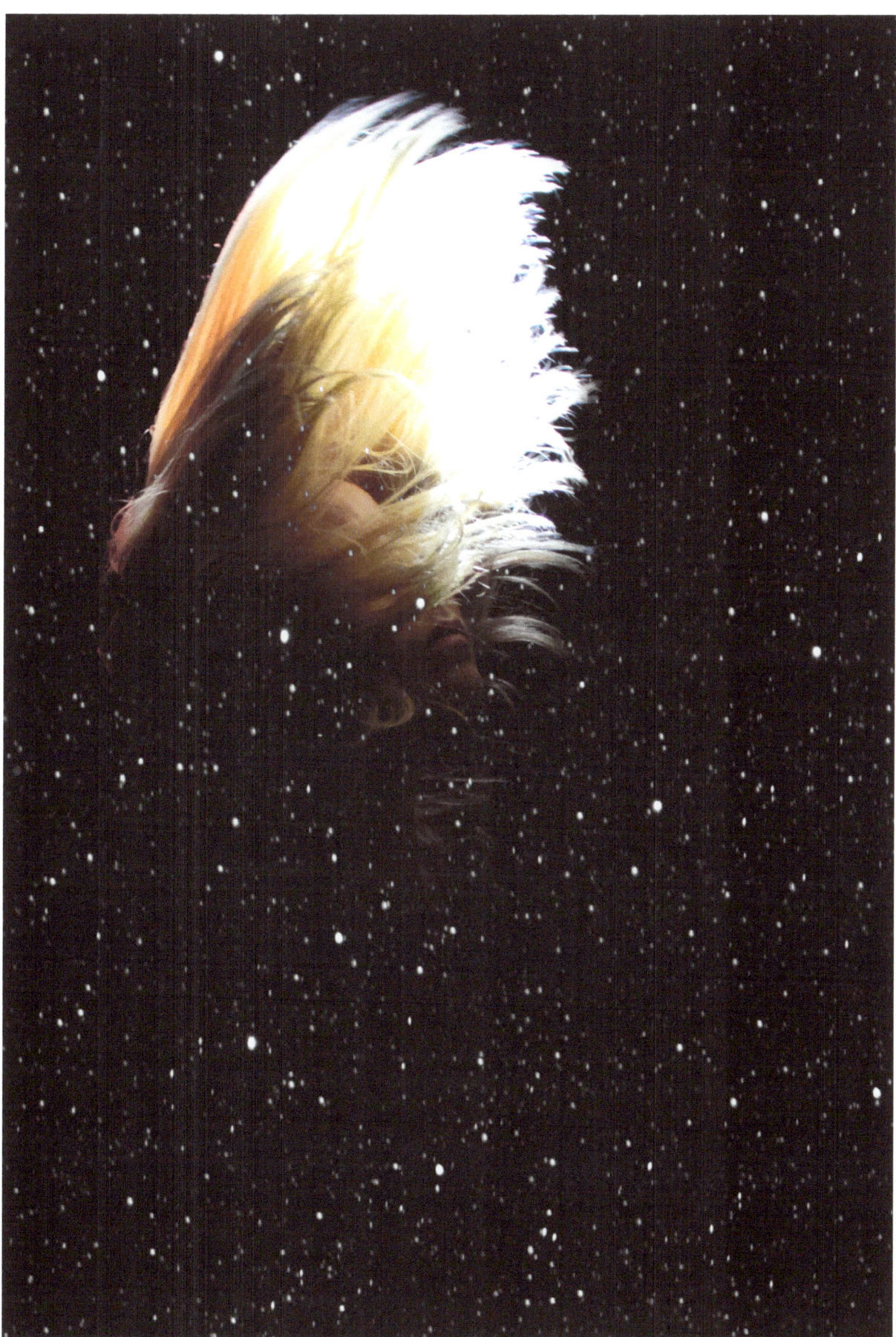

Drive on a Summer's Night

Days with all you need is 90 degree heat.

at night, driving home with the windows way open. Sweet scent of chardonnay tumbles down the town.

Heat to make knees

Riverbed weak.

Fish gets a rise and grease burgers through the thoroughfare.

Sweet scents of loves' flowers

dot the refrain.

Tear drops, like window panes, take glass back dusted all the way home.

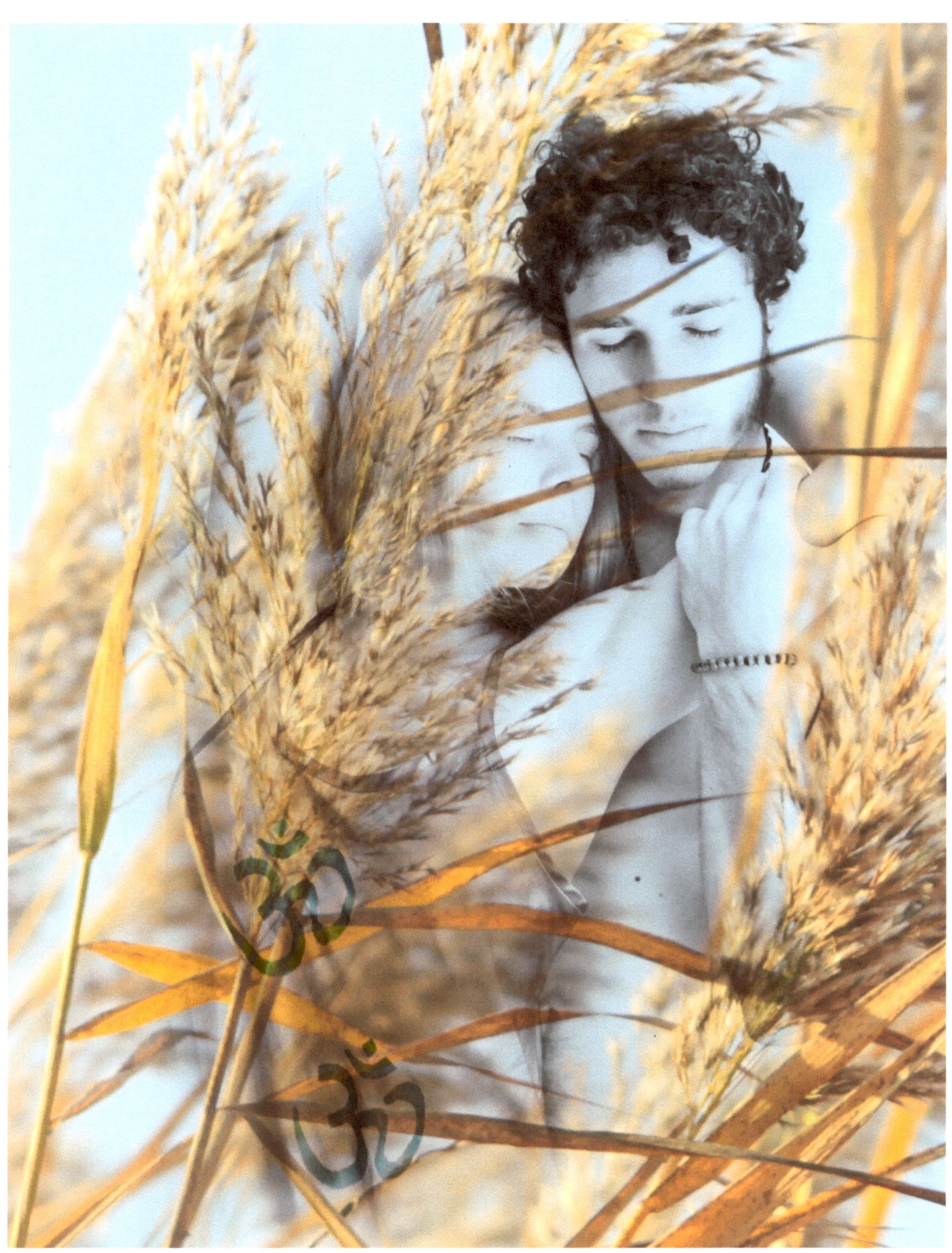

Birdie Bridge

Hands link vines,

Like veins,

they grow.

Pieces of patterns that don't let go,

blue and mint

turquoise and gold

tiny tumble abouts and steady for the pots they grow

Varies with age

and stage

wrapped gently in cellophane.

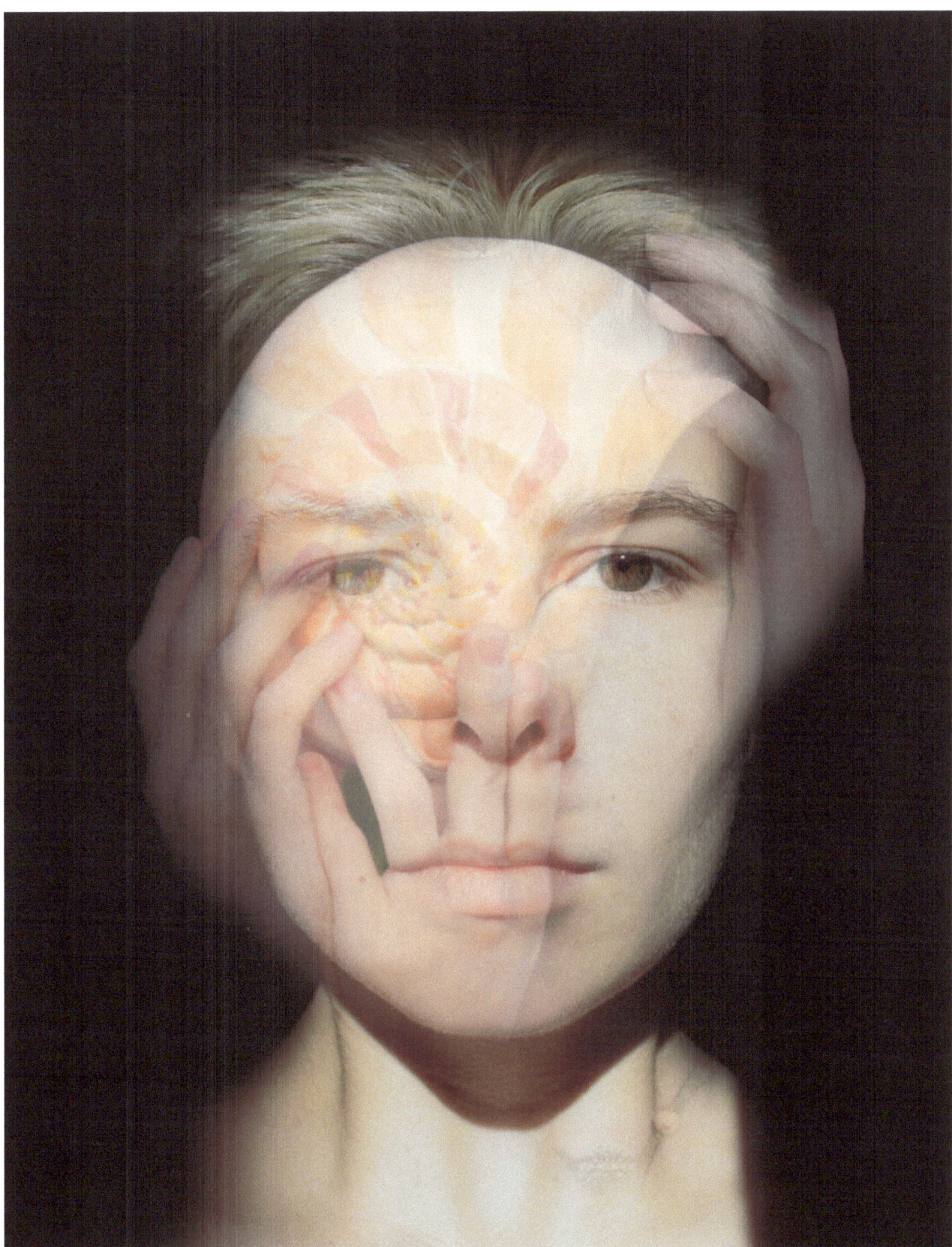

Purple Perfection

Drenched Deep,
In dark weeds

Green,
as hair,
grow.

Silver sparkles she leaves
behind her.

Crooning splatter speckles
from midnight matters.

Backseats filled with dreams,
bathtubs filled with laughter.

In|ten|cities
at stoplights.

Waterfalls come crashing down
Covering his face in silver spittle

Crescent Crystals
Satin Remains

Starlight will always find his way home.

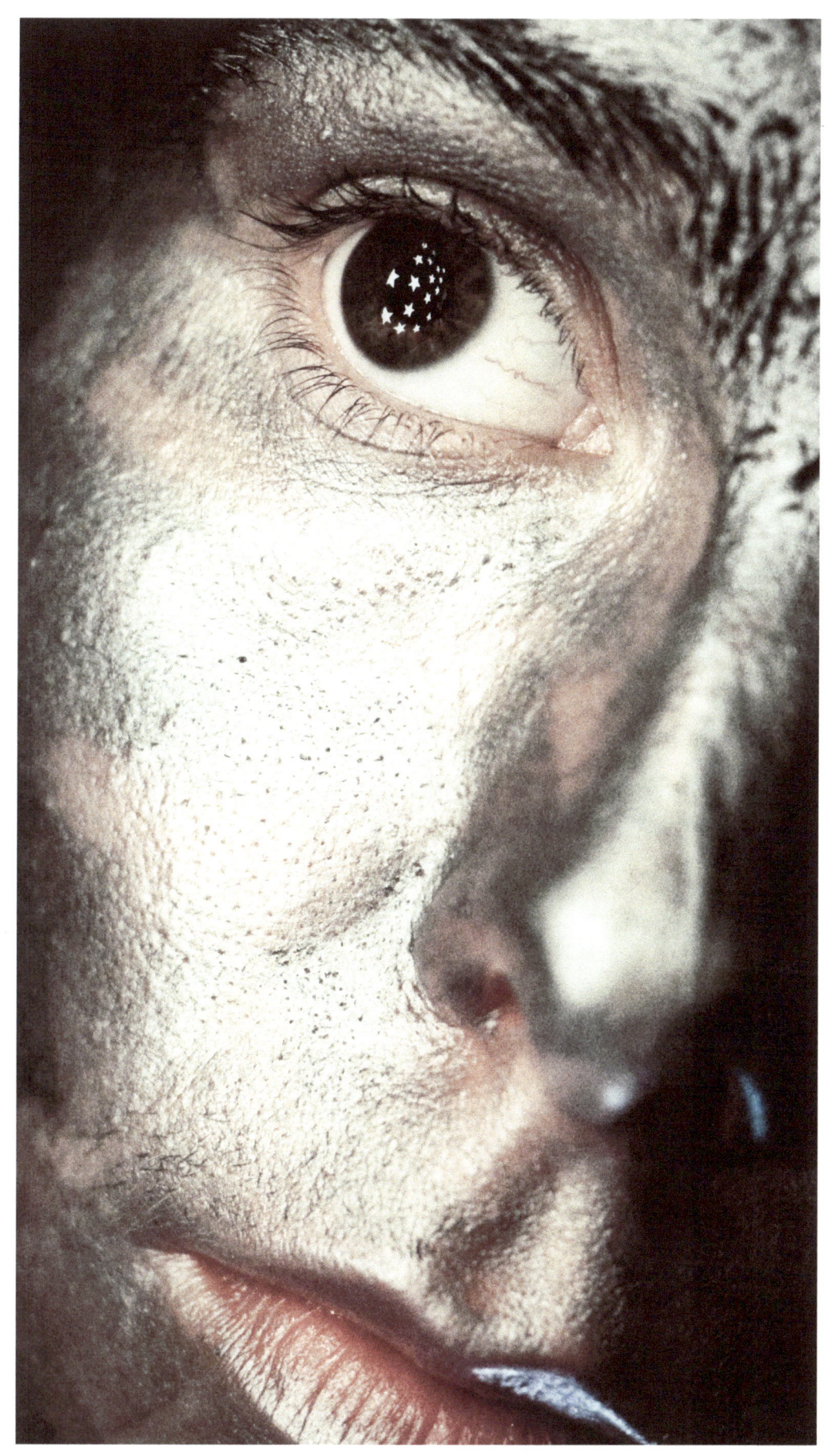

The Can, Can

I have a freshness in my life today that I can't quite understand. There is an aching in my body, there is a searching in my brain. Life has been shaking up and taking up the way I rearrange. I'm to a point, where the slate is clean. My brain washed to a crisp, white, ironed, T. It has reached a steadiness, a
sullenness, that sinks and stinks through all of the decades. A tousled turned fruit, that ripens at this page.

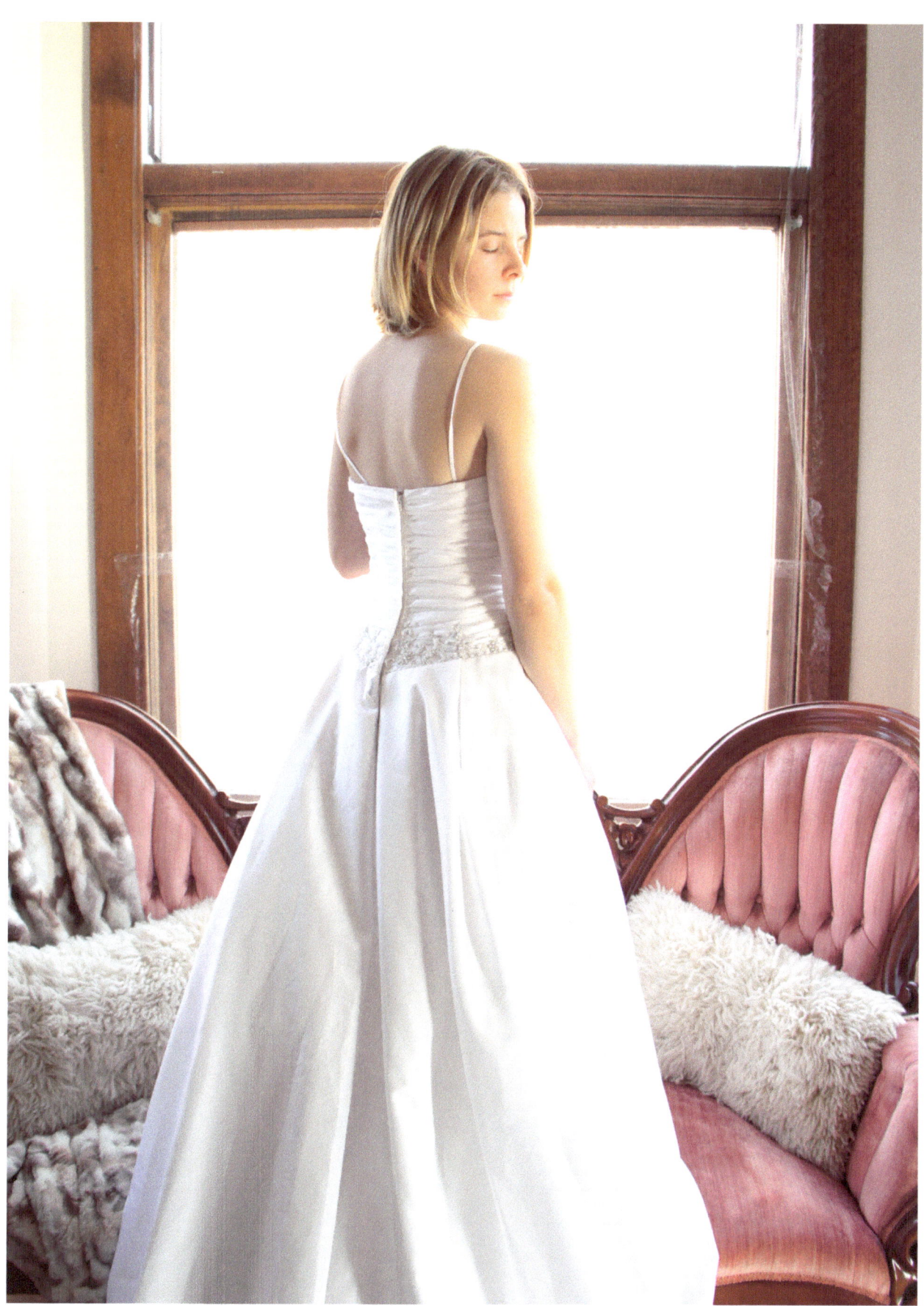

Special thanks to the following:

My mother, father, and Gohnie
Justin Sala for collaborating with me on every idea and everyway
A few select photo credits go to him as well
Kelsey Melin Howlett for taking the photo on the last page
Tuesdae & Kelly for listening and talking
Alissa and many others for adventures